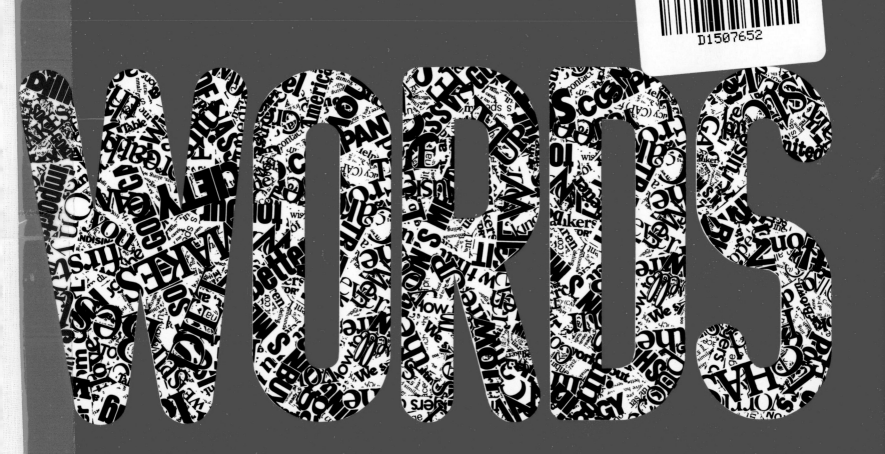

WORDS

Illustrated by Mark Soppeland and Friends

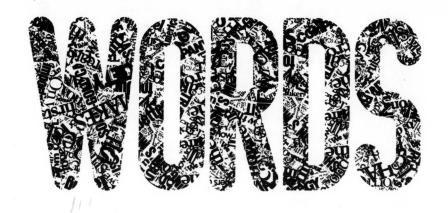

WORDS

Edited by

MARK SOPPELAND
The University of Akron

William Kaufmann, Inc. Los Altos, California

Front cover design: Mark Soppeland

ISBN 0-913232-60-2

Contents

Preface

Words. Learned, written, seen, read, spoken, heard—even dreamed. Words are used by all of us continuously and in various ways. Yet words are seldom contemplated as words. Expressed properly and opportunely, the utterance of one word can be vivid and memorable. But repeat the same word a hundred times in succession and it dissolves into meaningless sound.

It will serve most of us well to give more thought to these vehicles of communication and imagery, abstractions in service of our "real" world, these tools we happily ignore subconsciously so long as we "get the picture."

Words, then, is a book that aims to counteract our mental habit, for it asks us to pause and focus our attention on an individual word or pair of words. Contemplated free of sentence and paragraph, the word illuminates itself; it becomes the picture. Confronted by sheer words in forms that powerfully convey their meanings, our insight deepens and our appreciation grows for these unique strings of letters.

I first became interested in drawings of words in 1975 when I began teaching art at The University of Akron and was concerned with developing a series of drawing and design projects for my classes. In the explorations of artists who have worked with decorative alphabets and graphically manipulated words, I saw the possibility for a classroom assignment. The "word problem" was to draw and letter a word so that it remained legible as a word while illustrating what the word defined. This was an attractive

assignment in that it allowed me to present a number of design concepts and techniques while encouraging my students to research a variety of ideas of their own.

As the project developed, I became very excited by the quality of the results, and in 1979 began to explore the possibilities for publication. With the signing of a publication agreement, I sent out word that I needed "words" for *Words*. In response, hundreds of drawings were submitted by students, colleagues, friends, and friends of friends, and from these submissions I tried to select those that seemed most interesting. The result shown in this book represents over three thousand person-hours of work by contributing artists and designers.

The drawings in *Words* have been grouped according to the categories listed in the Contents. The grouping was loosely based on the functions of the words and was conducted only after final selections were made. In other words, the word drawings are organized to avoid randomness, but each drawing should be discovered for itself. The alphabetical index at the end of the book allows individual drawings to be quickly located.

Thanks to the efforts of the contributing artists and designers, *Words* will be entertaining and educational for anyone who enjoys the interplay of language and ideas. The right to use and enjoy this book extends to commercial artists and graphic designers, who will find *Words* a practical source of ideas, styles, and techniques. It will also provide a stimulating approach to the development of vocabulary and visual awareness in children and other new readers. Teachers who use it in teaching classes are invited to share their experiences by sending their suggestions and comments to me in care of the publisher. For my part, I hope many of you will be caught up in the spirit of this book; it would be great fun for me to see copies of your own "*words*" in print.

MARK SOPPELAND

1. Words about Words
Their Nature and Manipulation

SYL LA BLES

Morse Code by Kimberly Young

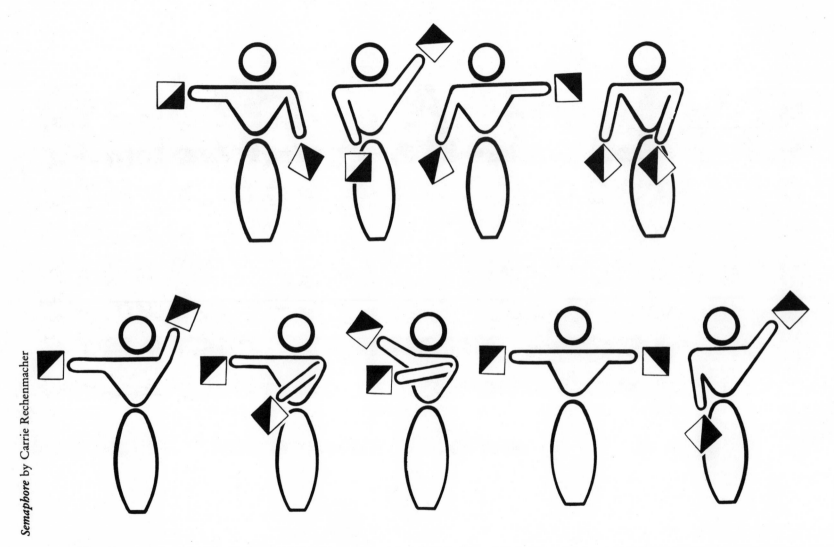

4 WORDS

Hieroglyphic by Tish Murphy

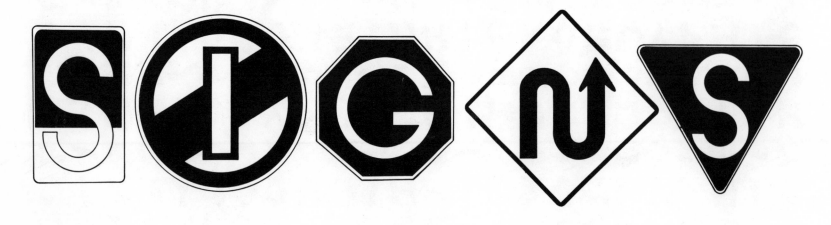

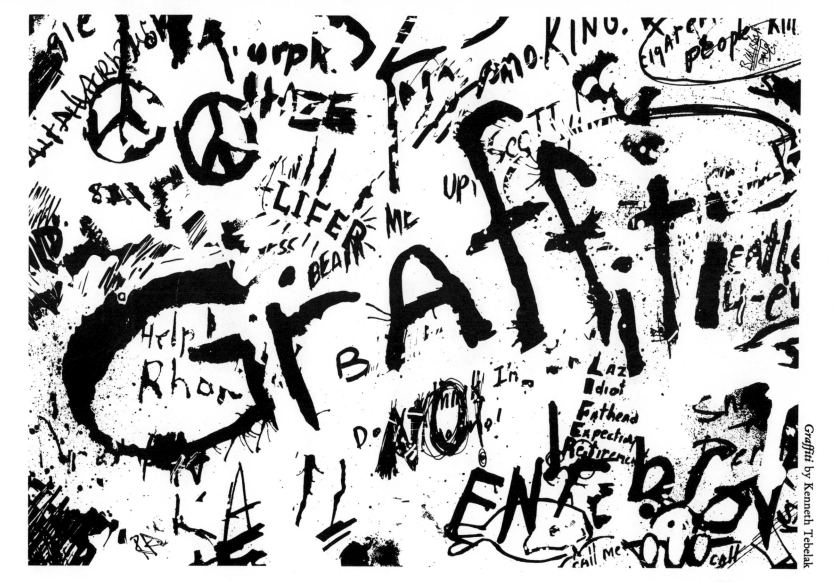

Graffiti by Kenneth Tebelak

STENCIL

ditto

Ditto by Cyndi Thompson

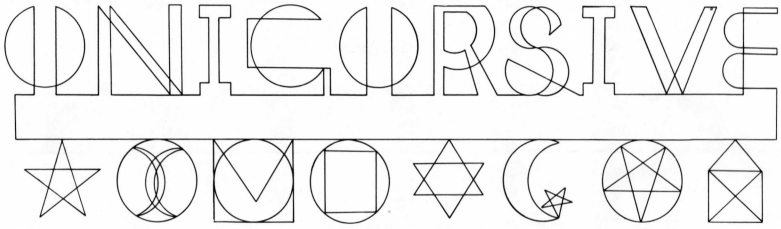

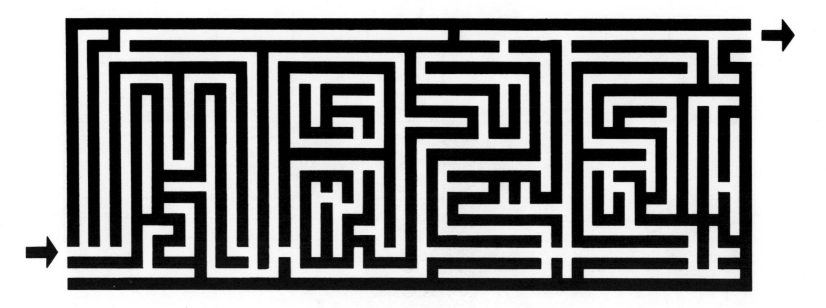

Maze by Tish Murphy

The crossword grid contains the following numbered cells and handwritten letters:

- 19, 20 (top row)
- 24 (with handwritten **W**), 25
- 28 (with handwritten **C**), and the across word **CROSS**, 29
- 35, 36, 37, with handwritten **R** below the O of CROSS
- 39, 40 (with handwritten **D**)
- 45, 46, 47
- 51

The handwritten letters spell **CROSS** across and **WORD** down.

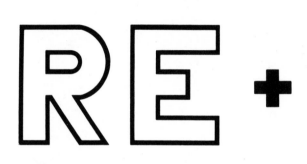 +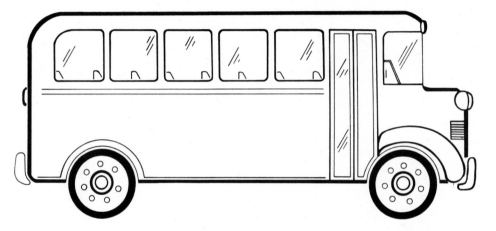

Abstract by Mark Soppeland

E[QU]A/T=10^N

Equation by Mark Soppeland

MISPELL

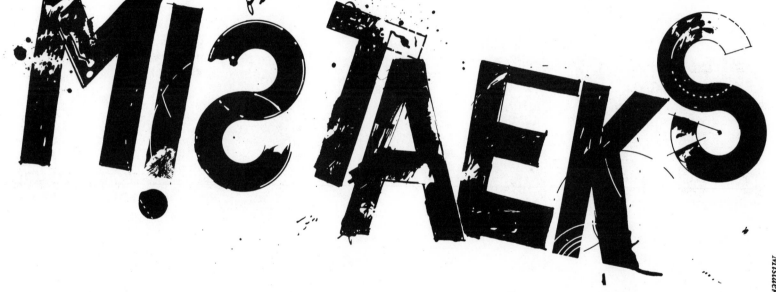

MISTAEKS

Mistaeks by Mark Soppeland

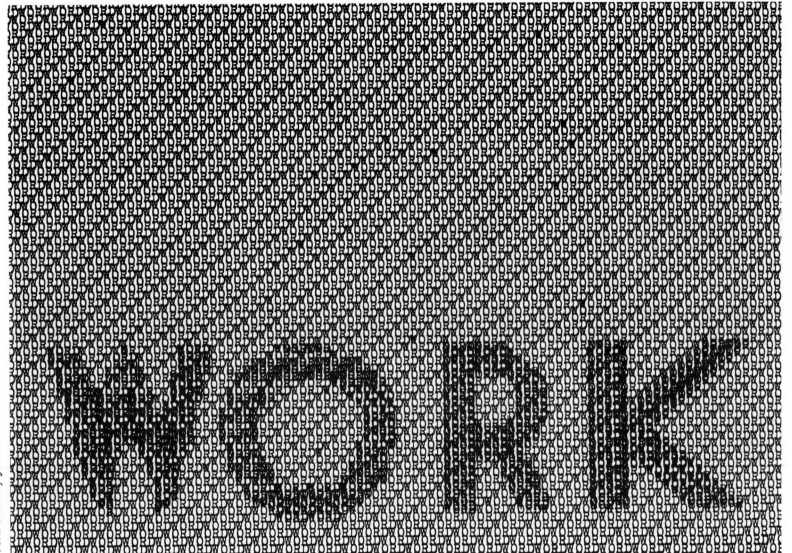

18 WORDS

2. Words that Characterize
The Status of Things

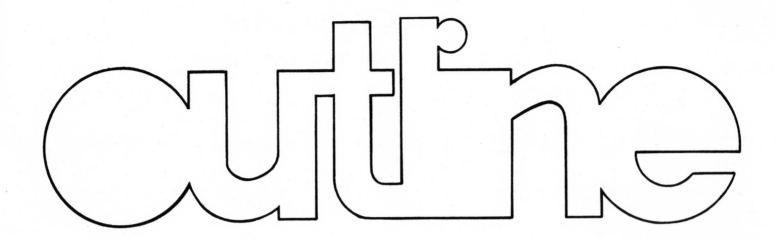

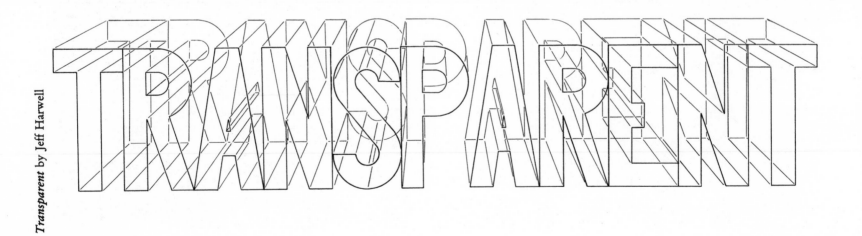

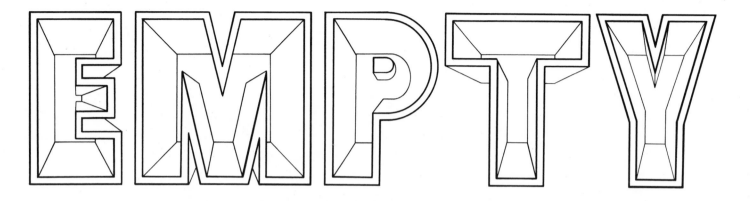

Empty by Edward Seavert

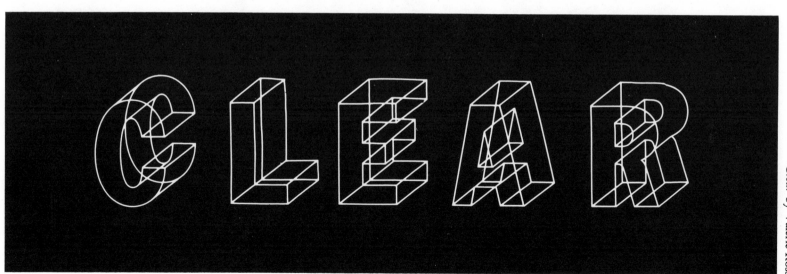

Clear by Valerie Ross

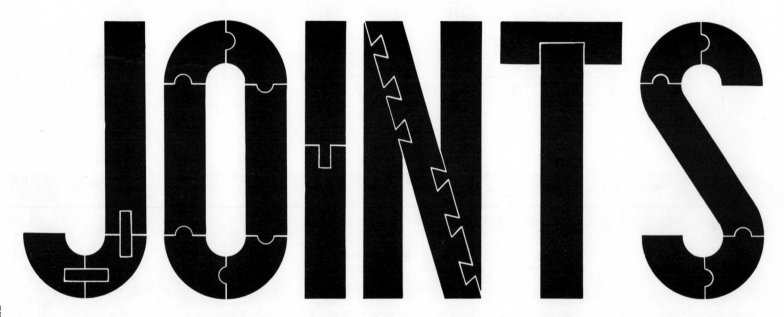

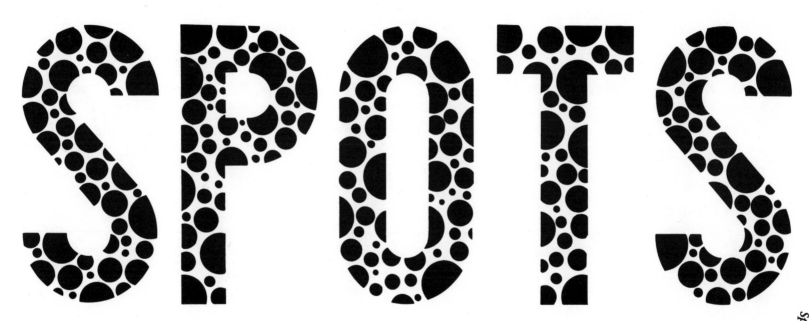

Spots by Laura Broderick

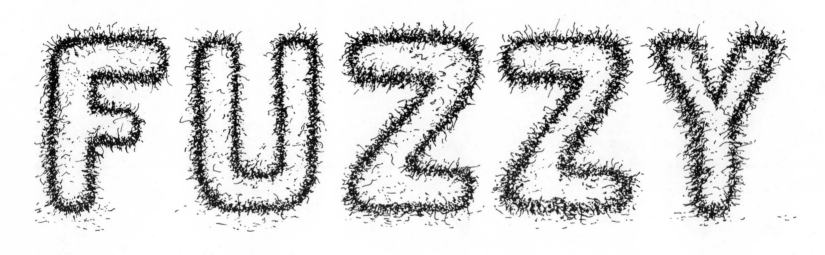

gradation

Gradation by Lori Champoir

BLACK
WHITE

Black/White by Mark Soppeland

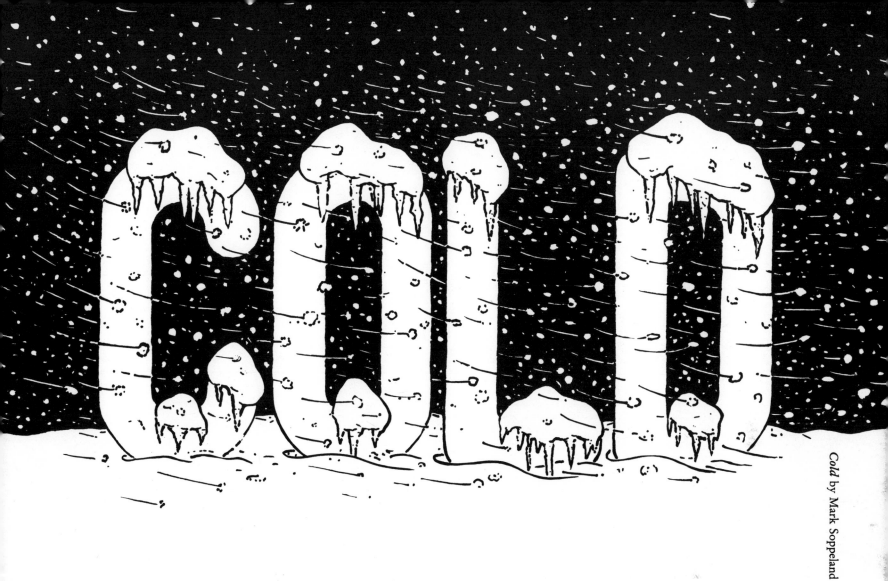

Cold by Mark Soppeland

ELABORATE

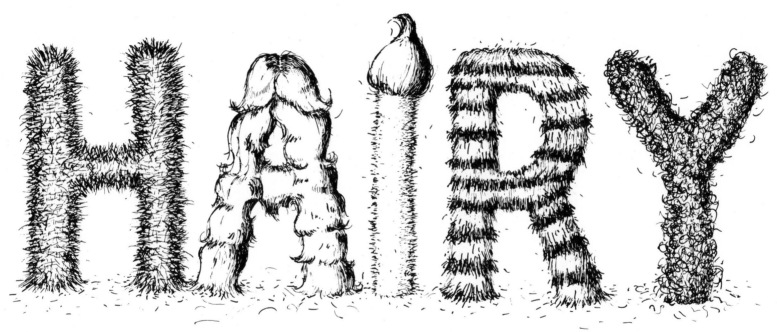

SMALL

Small by Mark Soppeland

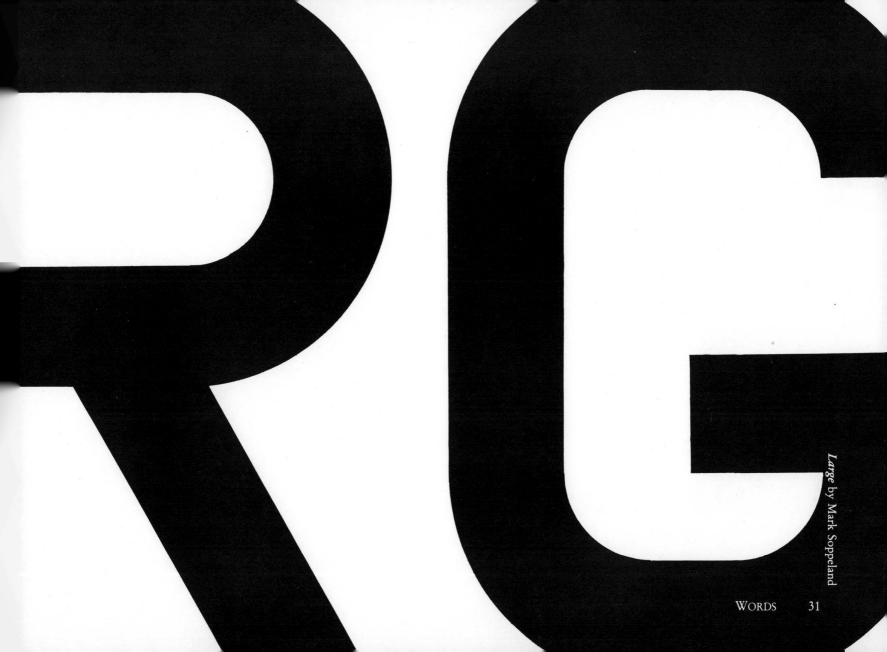

Large by Mark Soppeland

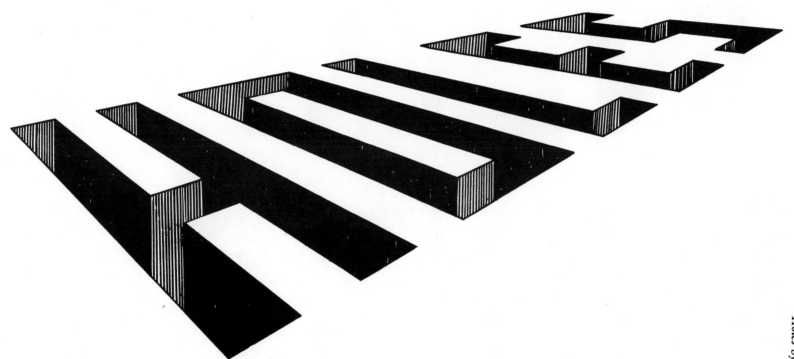

Holes by Mark Soppeland

NEATH
UNDER

Underneath by Mark Soppeland

C S K Y V E N U Q M

V M N F O L T E I P

A J H I D D E N G R

P Q S U O T W X B K

N F L Z R G M J O H

BACKWARDS

Backwards by Kimberly Young

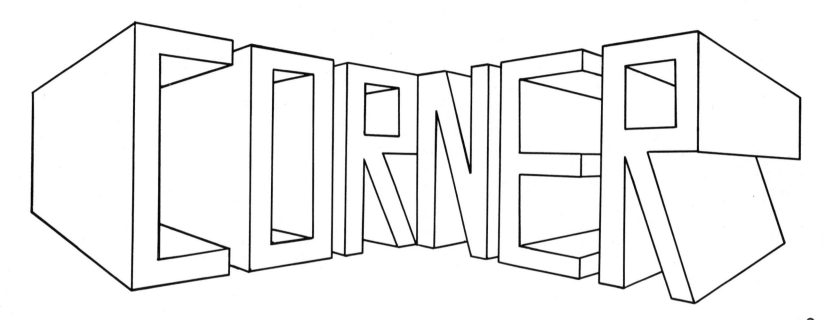

T
RI
ANG
ULAR

Squares by Darryl Foster

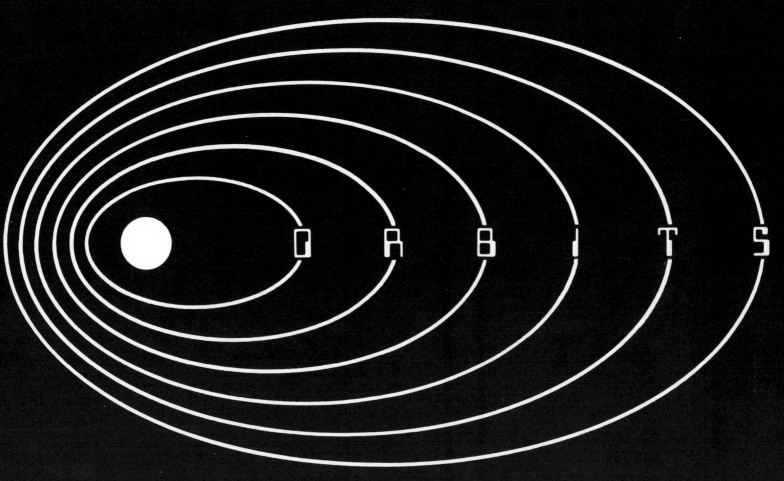

WORDS

Directions by Mark Soppeland

3. Words of Substance
The Material World

44 WORDS

CHROME

Chrome by Raymond Eish

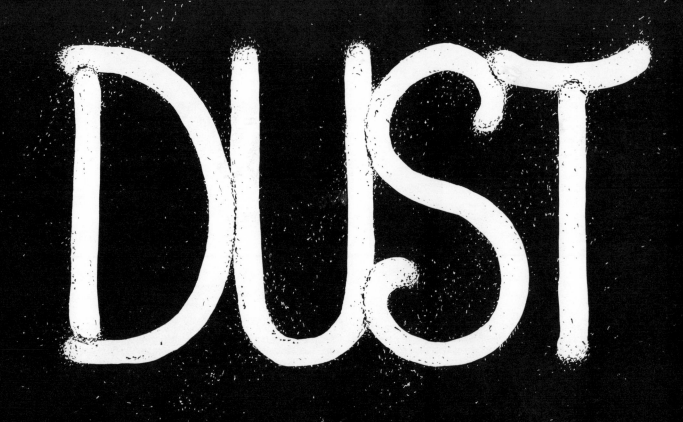

Dust by Edward Seavert

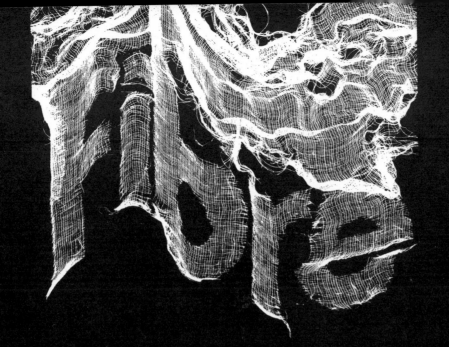

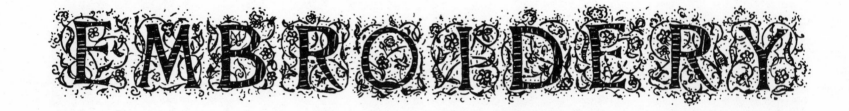

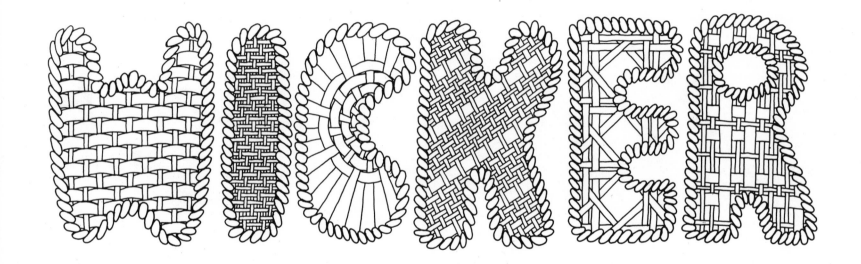

Wicker by Elaina Scuderi

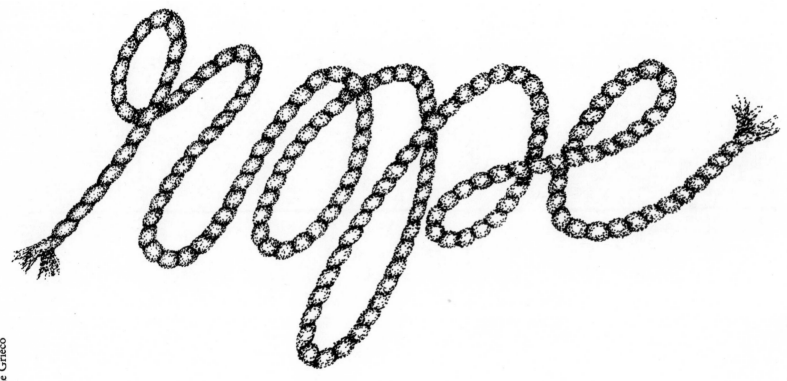

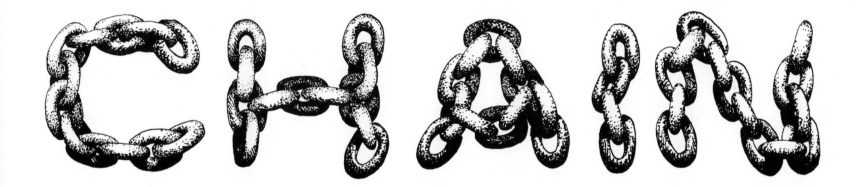

Chain by Ronna Cullen

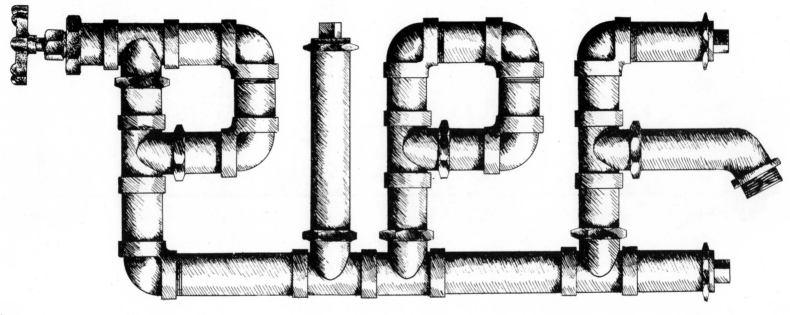

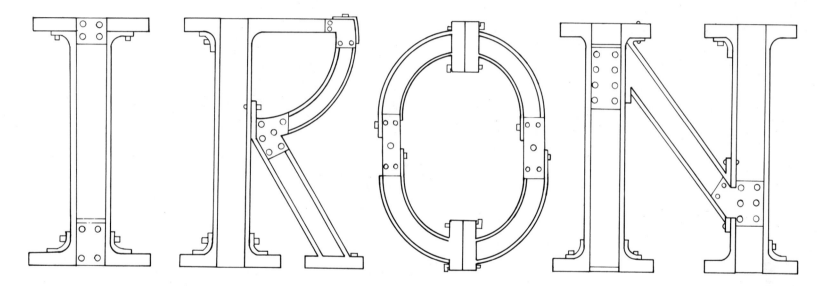

Iron by Robert Palmieri

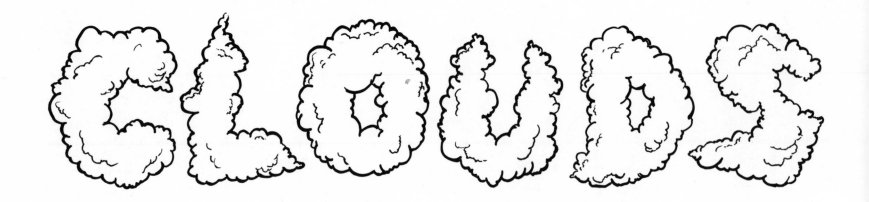

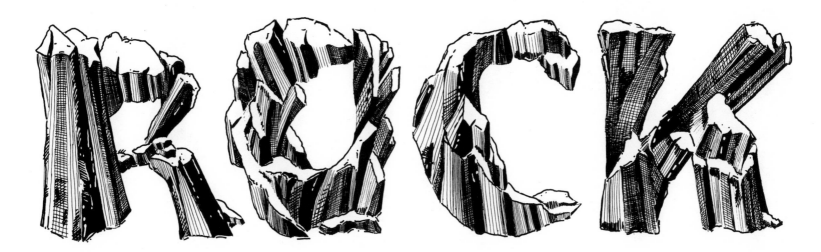

Rock by Pamela Stuteville

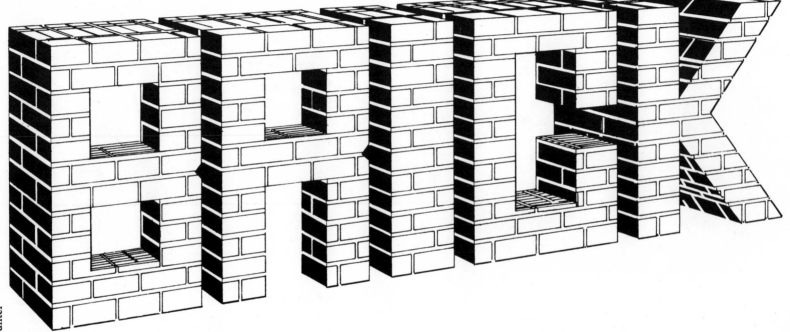

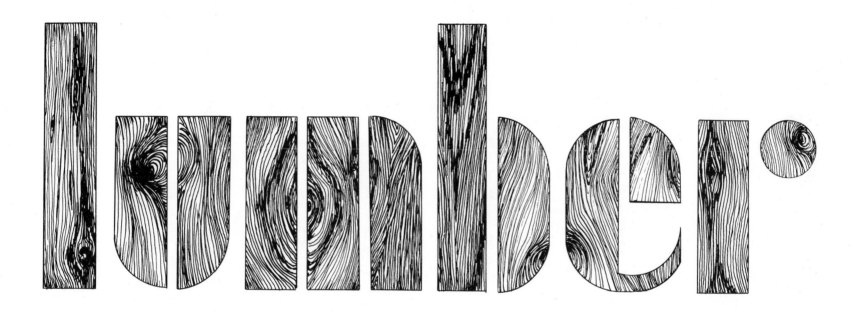

Lumber by Ronna Cullen

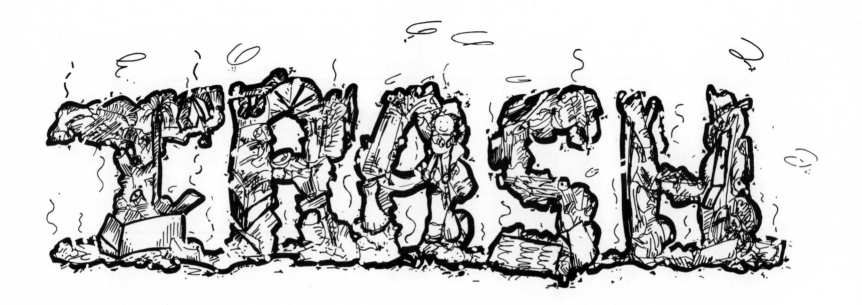

Trash by Eugena Wingard

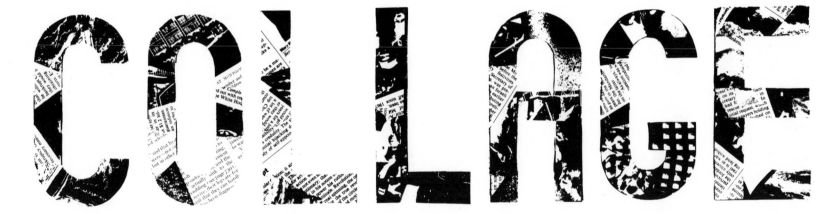

Collage by Mark Soppeland

4. Words in Our Midst

Food, Clothing, and Everyday Objects

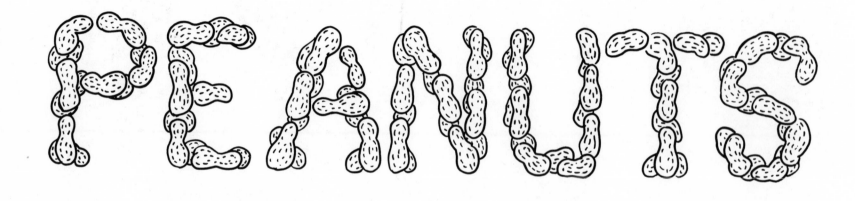

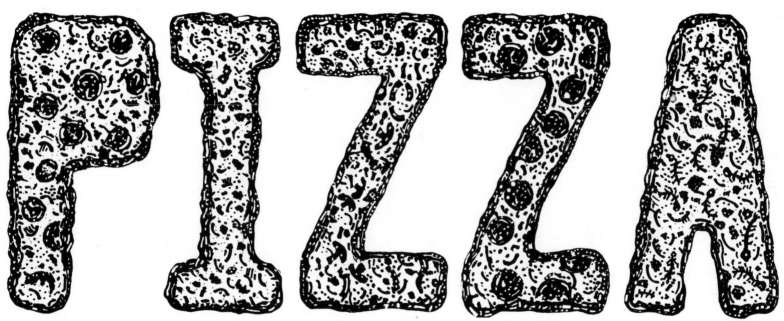

Pizza by Mark Soppeland

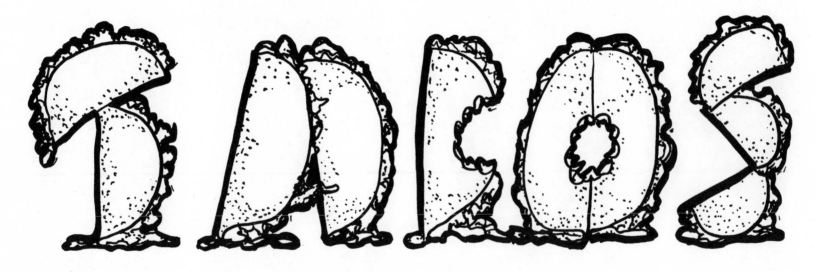

Tacos by Eugena Wingard

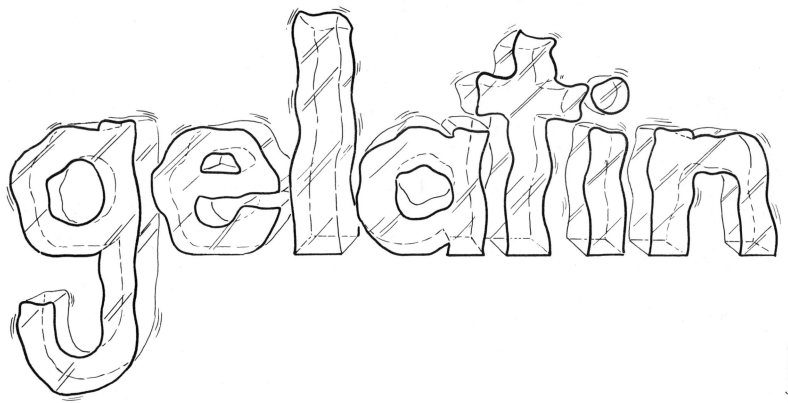

Gelatin by Gordon McLain

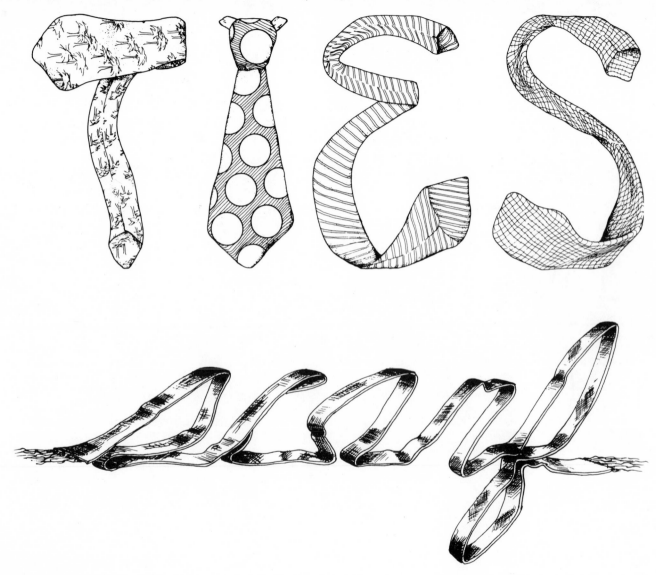

Ties by Susan Hayes

Scarf by Dennis Werntz

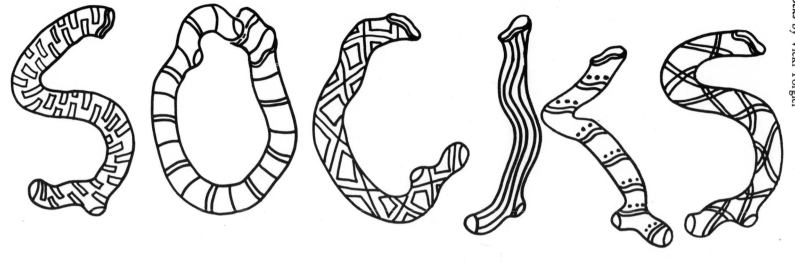

Socks by Vicki Torgler

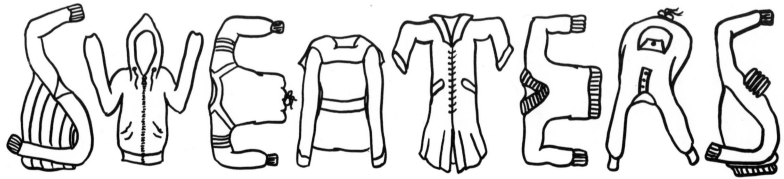

Sweaters by Elaina Scuderi

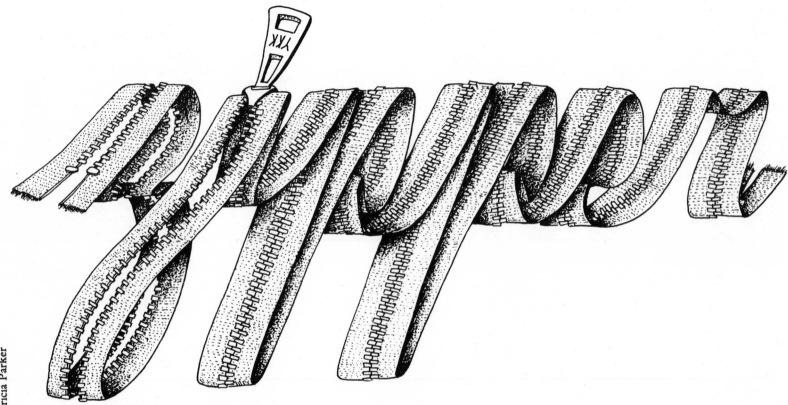

Zipper by Patricia Parker

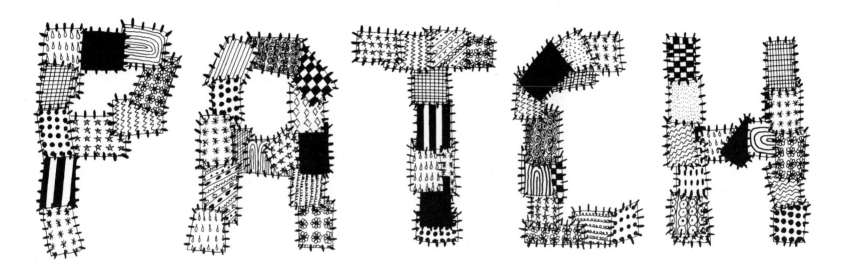

Patch by Sharon Crockett

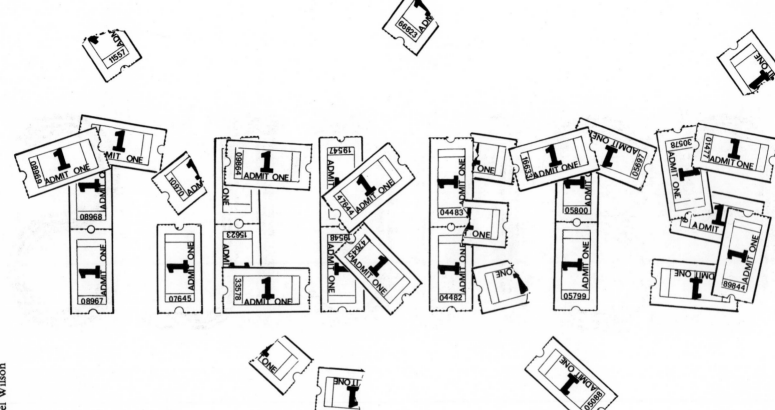

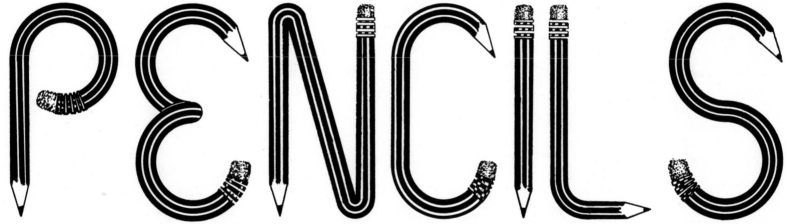

Pencils by Mark Soppeland

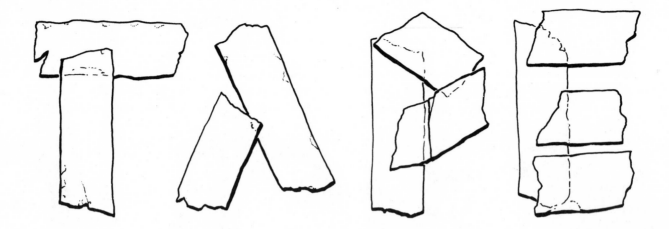

Tape by Ronna Cullen

Wrench by Mark Soppeland

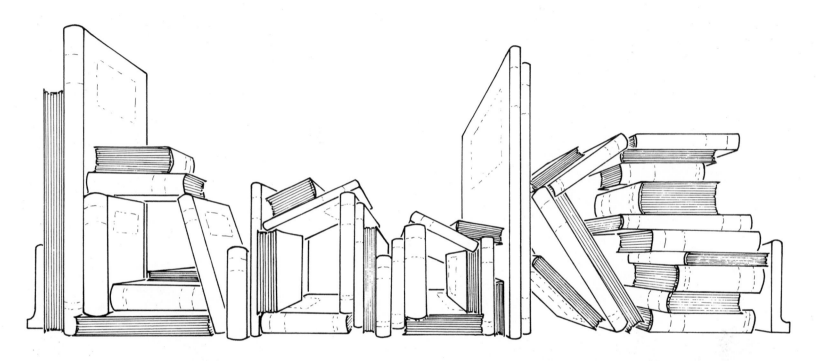

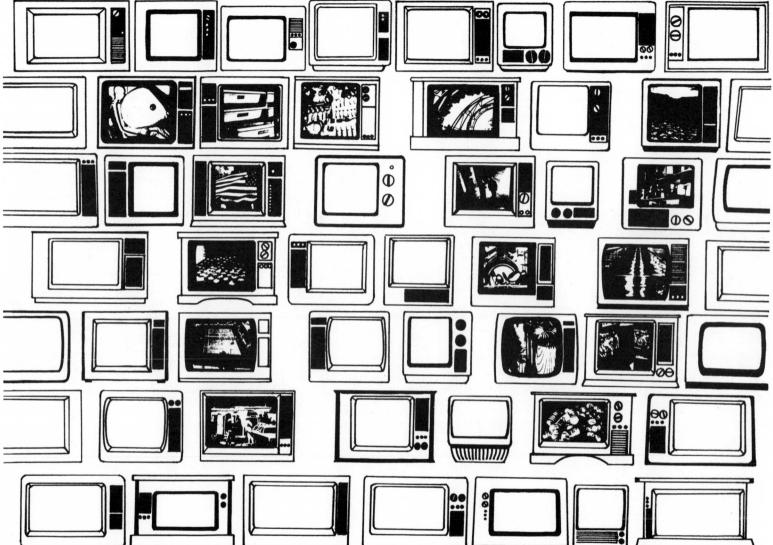

TV by Robert DiPaolo

Radio by Kevin Reagh

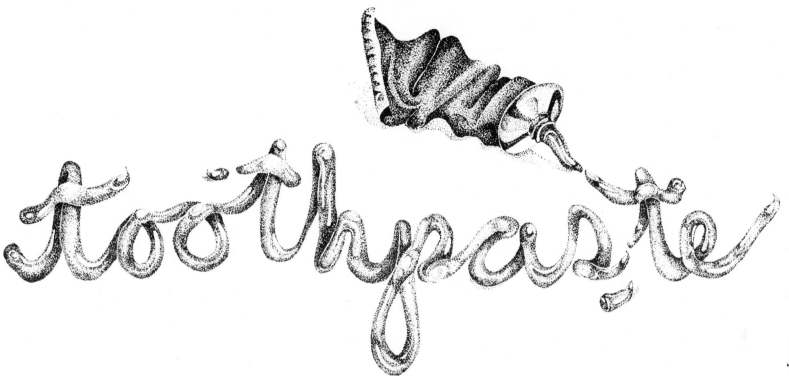

Toothpaste by Kristen Lanshe

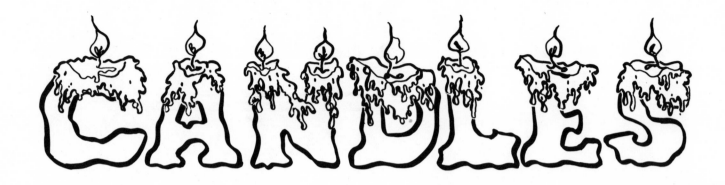

5. Words that Live
Plants, Animals, and People

LEAVES

TOPIARY

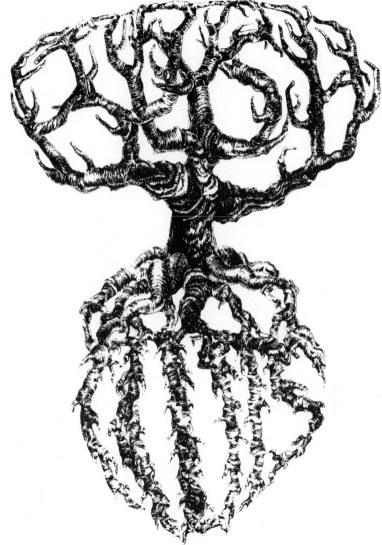

Bush/Roots by Cathy Piperni

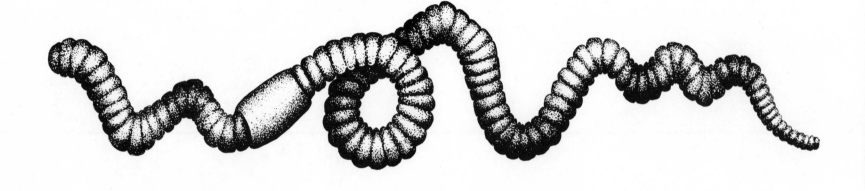

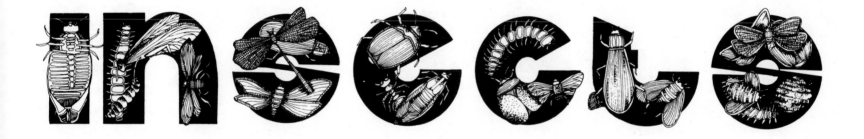

Insects by Carol Bresney

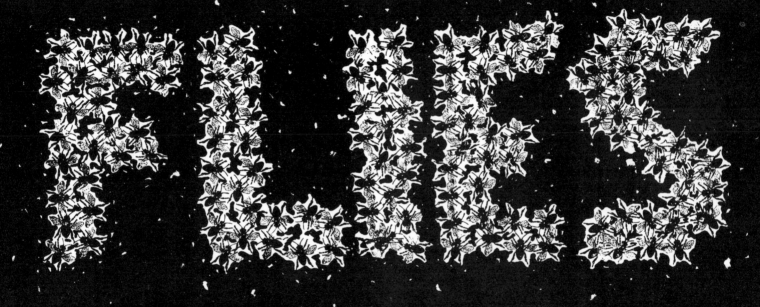

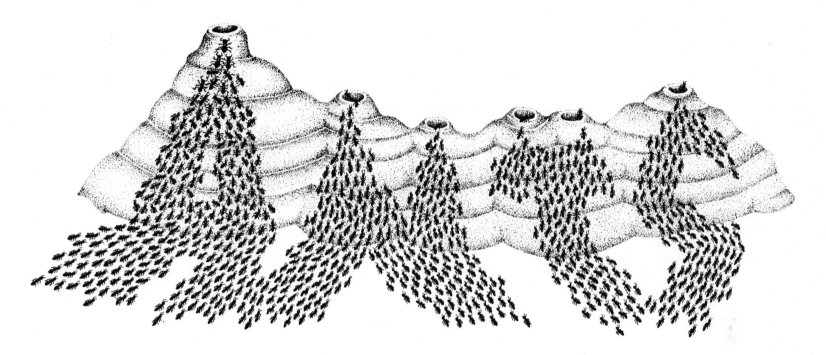

Ants by Frank Mitchley

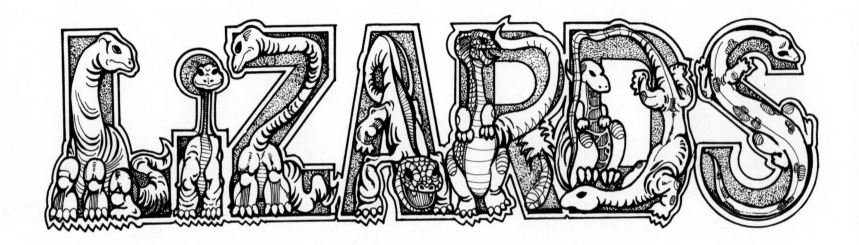

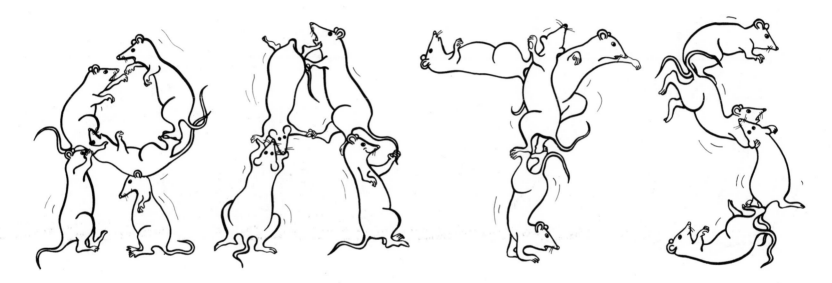

Rats by Robert Palmieri

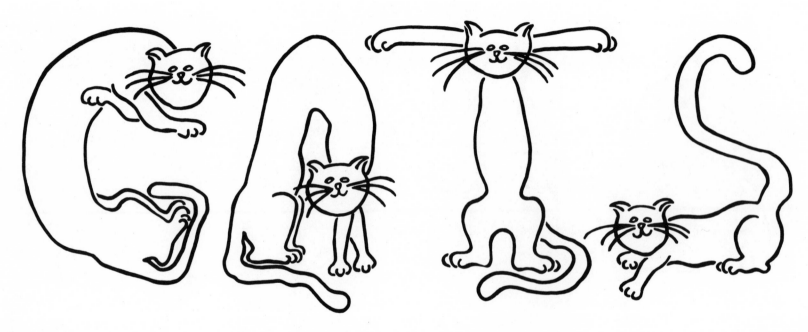

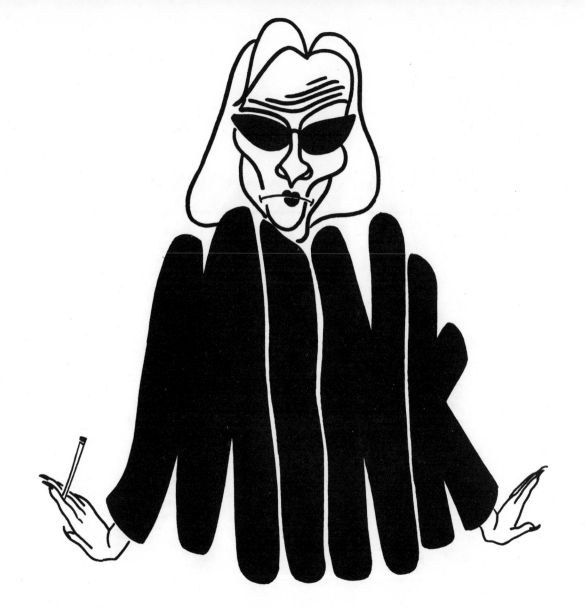

Mink by Gordon McLain

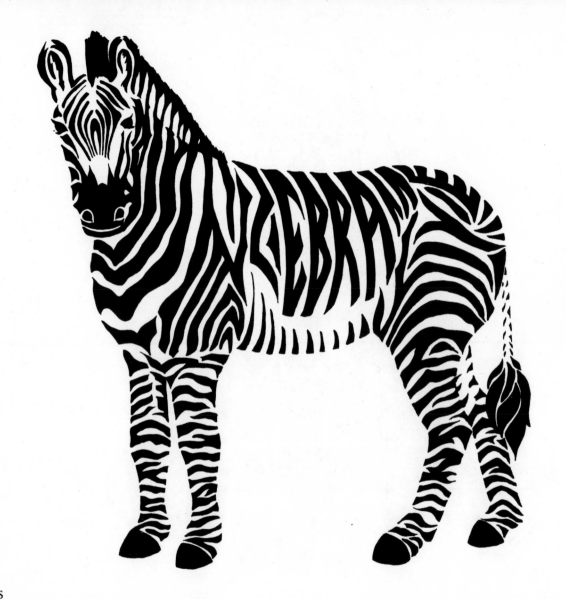

90 WORDS

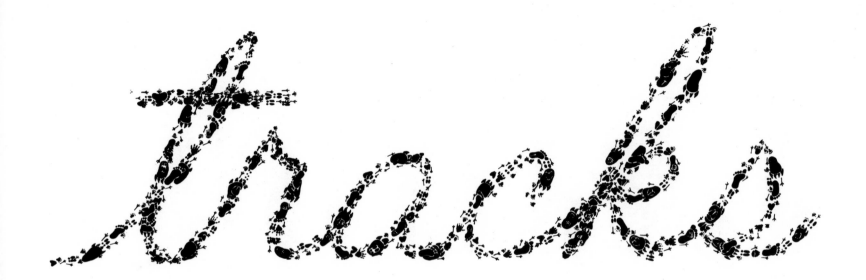

Tracks by John Pappas

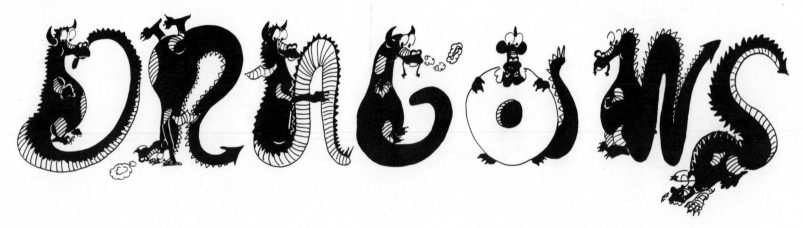

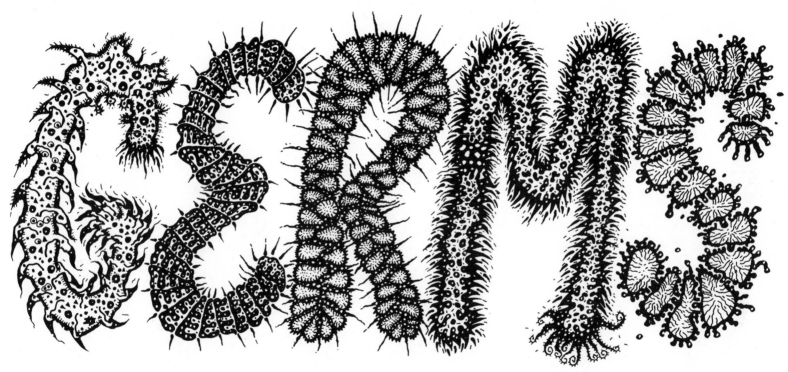

Germs by Mark Soppeland

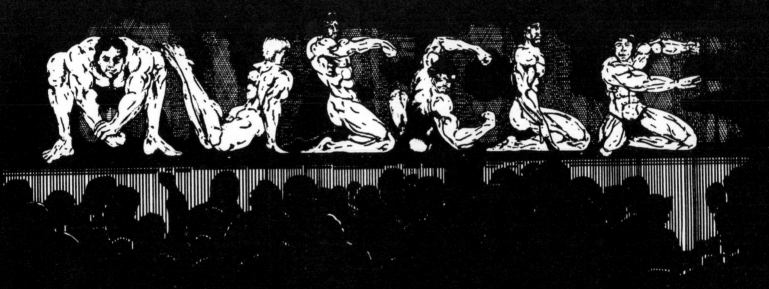

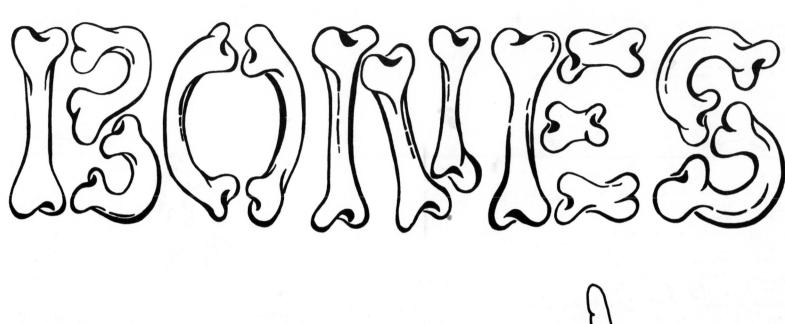

Bones by Robert DiPaolo

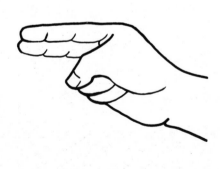

Hands by Ruth Anne Deppen

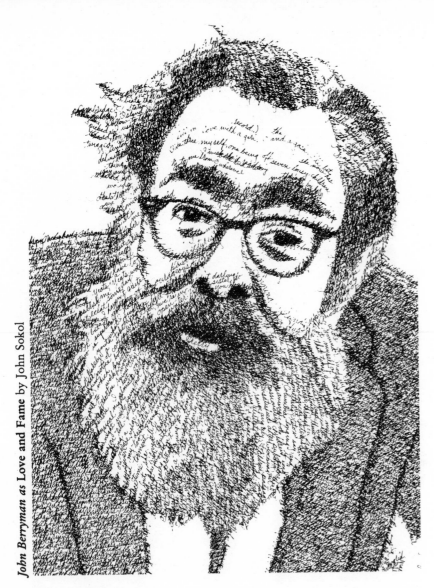

96 WORDS

George Bernard Shaw as Arms and the Man by John Sokol

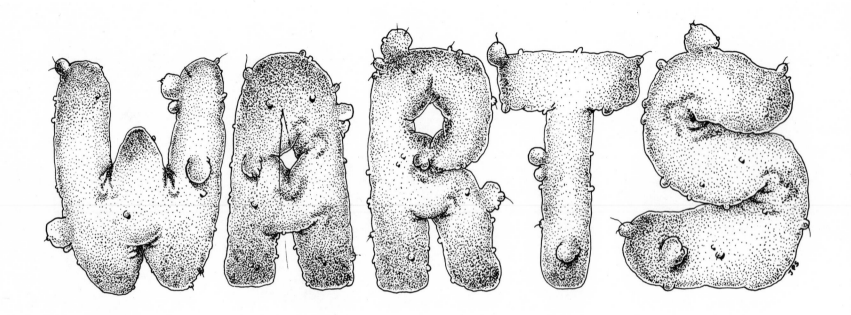

6. Words of Action and Change

Processes and Movement

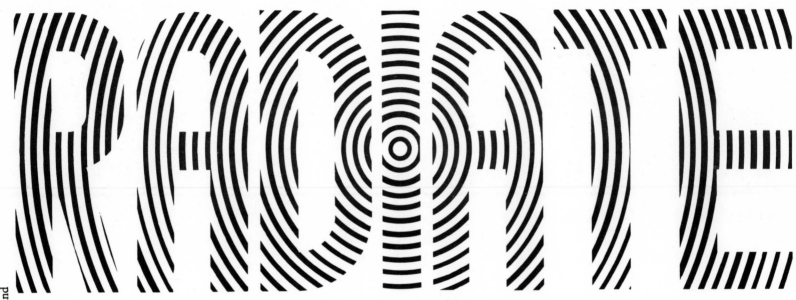

100 WORDS

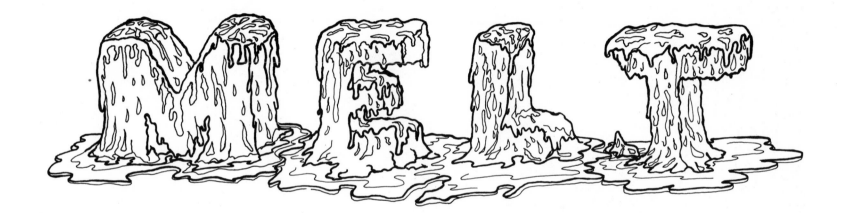

Melt by Eileen Johnston

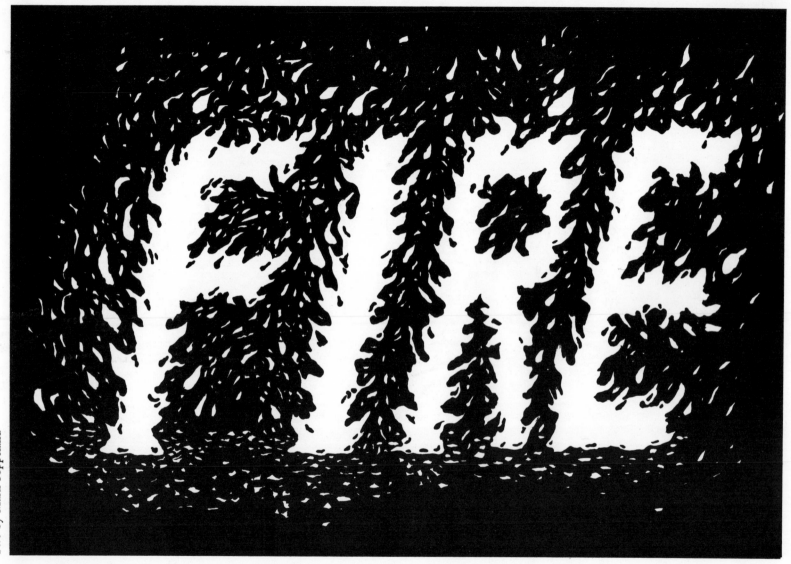

Clausius: the measure of disorganization for a closed system. According to Clausius: the measure of disorganizat
lausius: the measure of disorganization for a closed system. According to Clausius: the measure of disorganizati
ausius: the measure of disorganization for a closed system. According to Clausius: the measure of disorganizatio
usius: the measure of disorganization for a closed system. According to Clausius: the measure of disorganization
sius: the measure of disorganization for a closed system. According to Clausius: the measure of disorganization
ius: the measure of disorganization for a closed system. According to Clausius: the measure of disorganization f
us: the measure of disorganization for a closed system. According to Clausius: the measure of disorganization fo
s: the measure of disorganization for a closed system. According to Clausius: the measure of disorganization for
: the measure of disorganization for a closed system. According to Clausius: the measure of disorganization for
 the measure of disorganization for a closed system. According to Clausius: the measure of disorganization for a
the measure of disorganization for a closed system. According to Clausius: the measure of disorganization for a
he measure of disorganization for a closed system. According to Clausius: the measure of disorganization for a c
e measure of disorganization for a closed system. According to Clausius: the measure of disorganization for a cl
 measure of disorganization for a closed system. According to Clausius: the measure of disorganization for a clo
measure of disorganization for a closed system. According to Clausius: the measure of disorganization for a clos
easure of disorganization for a closed system. According to Clausius: the measure of disorganization for a close
asure of disorganization for a closed system. According to Clausius: the measure of disorganization for a closed
sure of disorganization for a closed system. According to Clausius: the measure of disorganization for a closed
ure of disorganization for a closed system. According to Clausius: the measure of disorganization for a closed s
re of disorganization for a closed system. According to Clausius: the measure of disorganization for a closed sy
e of disorganization for a closed system. According to Clausius: the measure of disorganization for a closed sys
of disorganization for a closed system. According to Clausius: the measure of disorganization for a closed syst
of disorganization for a closed system. According to Clausius: the measure of disorganization for a closed syste
f disorganization for a closed system. According to Clausius: the measure of disorganization for a closed system
 disorganization for a closed system. According to Clausius: the measure of disorganization for a closed system.
disorganization for a closed system. According to Clausius: the measure of disorganization for a closed system.

```
isorganization          f     or    a        c       los         ed          sy    st   em.  According
sorganization       for a     cl   osed     syst   em.   A     ccor    di   ng      to   C   laus: the measur
organization f    or a c       l   osed     syst   em.   A     ccordin  g    to      Cla     usius: the measur
rganization fo      r a   c         lose    d sy       st    em. Acc   o          rdin   g to Clausius: the
ganization for    a clos   ed       syst   em.       Acc   ording  to      Clausi    us: the measure of
anization for    a clos   ed s     yste    m. A   c   cord    ing      to      Clausius:    the measure of dis
nization for a      c   lose      d sy    stem   .   Acc           ordi   ng to Cla    usius: the measure
ization for a       c   lose      d sy    stem   .   Acc           ordi   ng to Cla    usius: the measure
zation for a        c   lose      d sy    stem   .   Acc           ordi   ng to Cla    usius: the measure c
ation for a         c   lose      d sy    stem   .   Acc           ordi   ng to Cla    usius: the measure of
tion for a          c   lose      d sy    stem   .   Acc           ordi   ng to Cla    usius: the measure of
ion for a           c   lose      d sy    stem   .   Acc           ordi   ng to Cla    usius: the measure of (
on for a            c   lose      d sy    stem   .   Acc           ordi   ng to Cla    usius: the measure of di
```

Entropy by John Sokol

Vibration by Raymond Eish

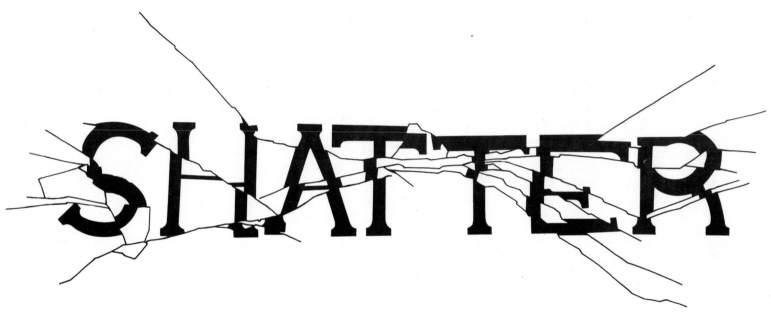

Shatter by Kenneth Tebelak

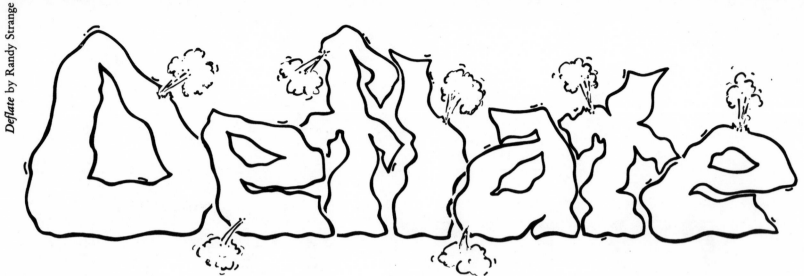

Deflate by Randy Strange

Deja Vu by Mark Soppeland

DEJA VU

MAGNIFY

Magnify by William Gunter

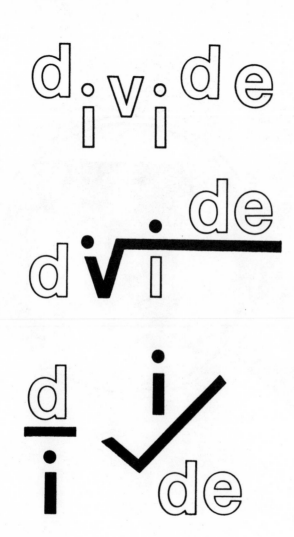

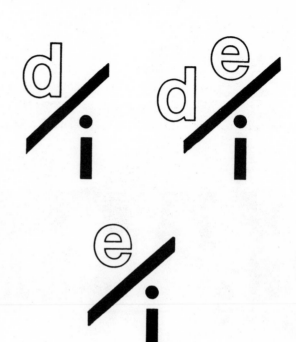

Divide by Nick Betro

ADD

SPLIT

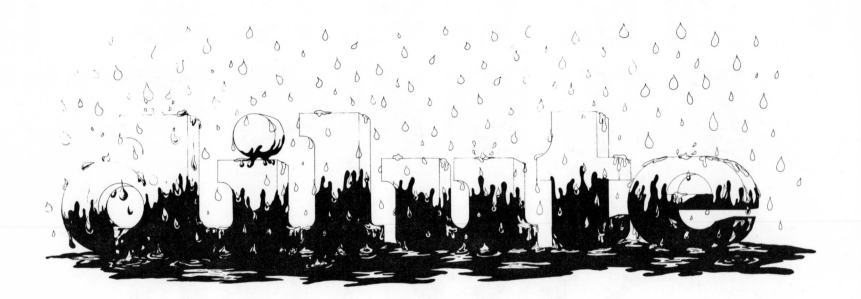

Dilute by Edward Seavert

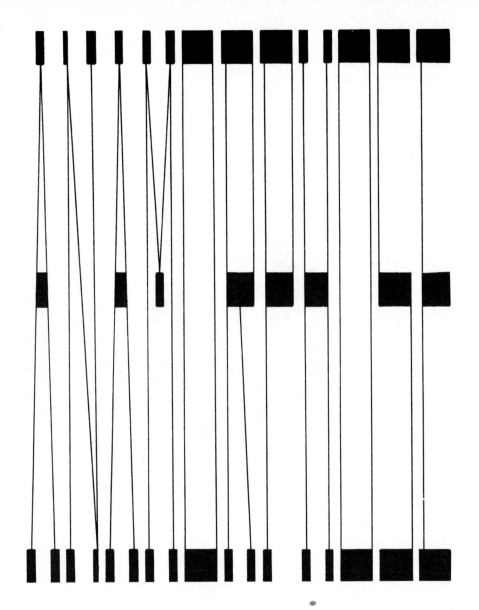

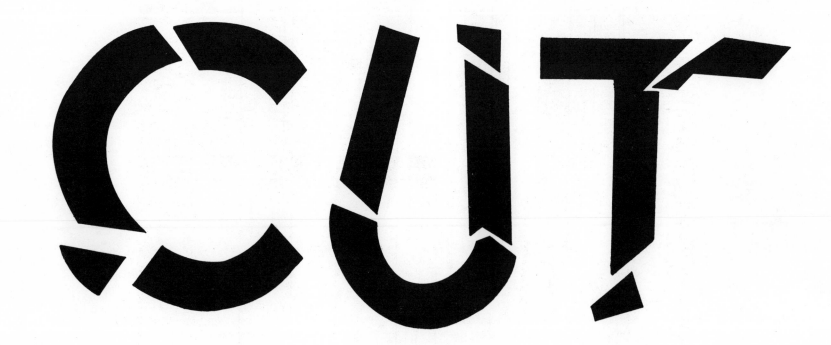

Cut by Maria Fatigati

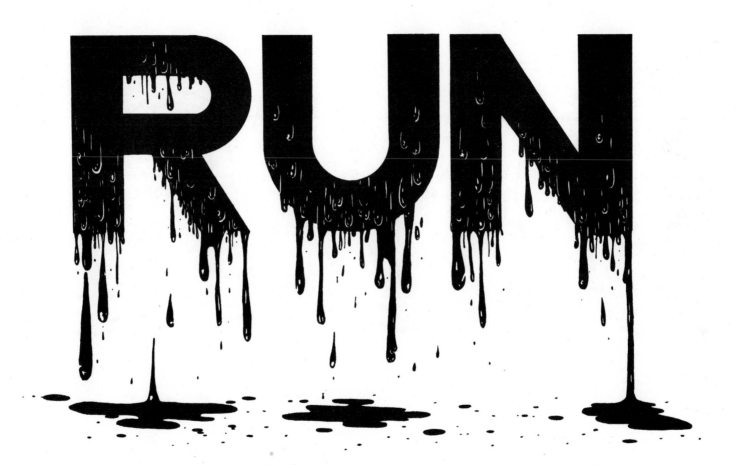

Run by Jeff Harwell

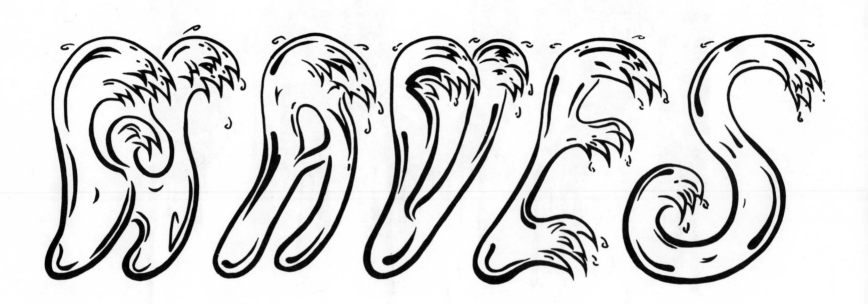

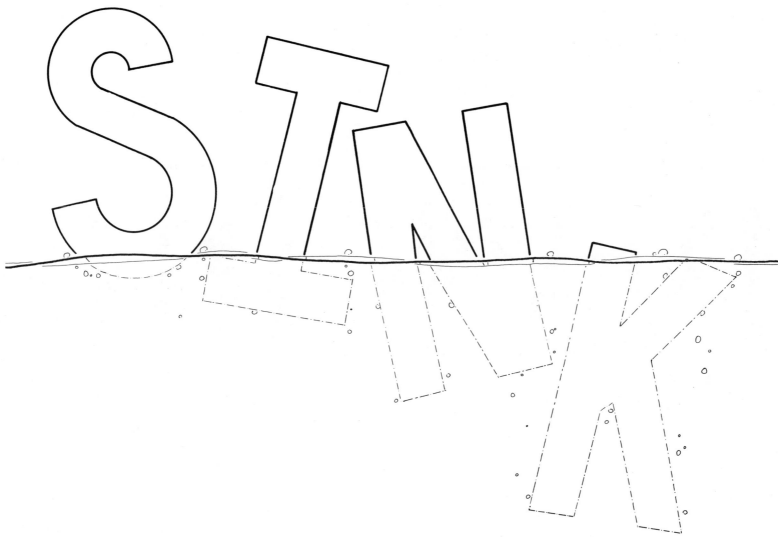

Sink by Susan Hayes

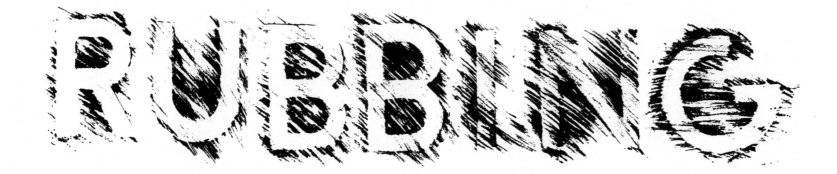

Rubbing by Amy Lindenberger

Woo by Tish Murphy

Weaving by Keith Hutchings

Plan by Mark Soppeland

Build by Jonathan Peterson

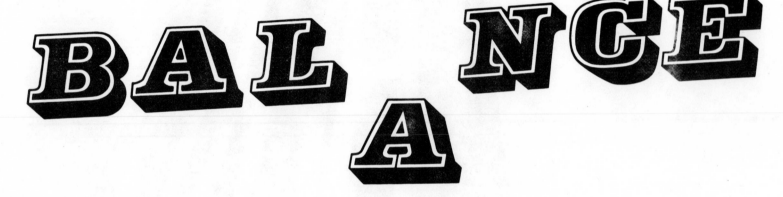

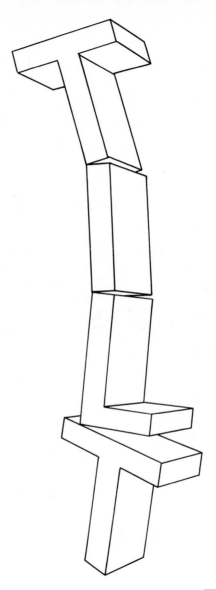

Tilt by Cyril Lawrence

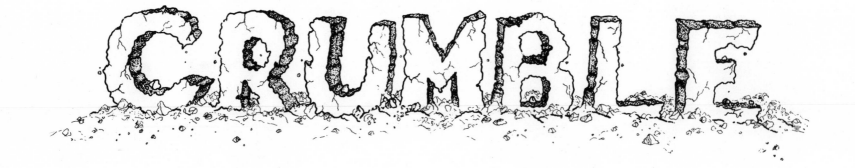

7. A Grab Bag of Words
Morning to Night

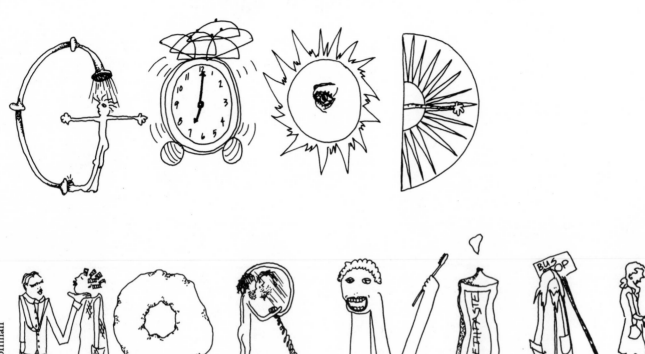

126 WORDS

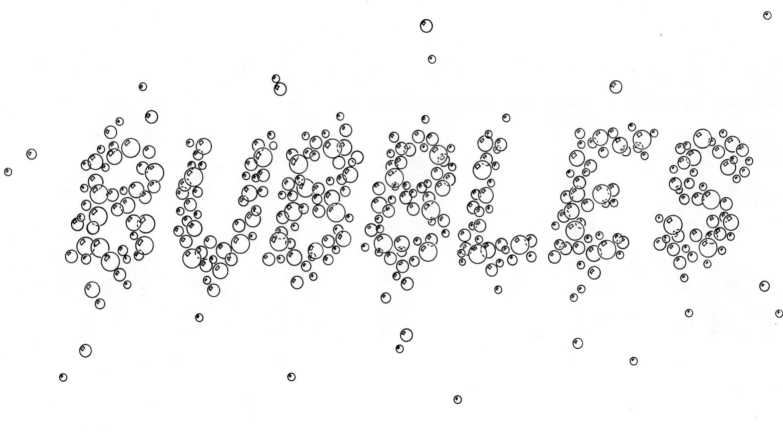

Bubbles by Lauren Balhorn

BITES

Bites by Kris Senn

BARBER

Barber by Randy Strange

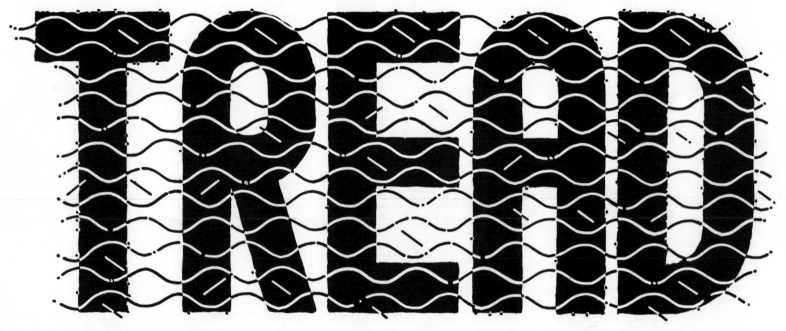

Tread by Mark Soppeland

INK SPOTS

Ink Spots by Brad Bebout

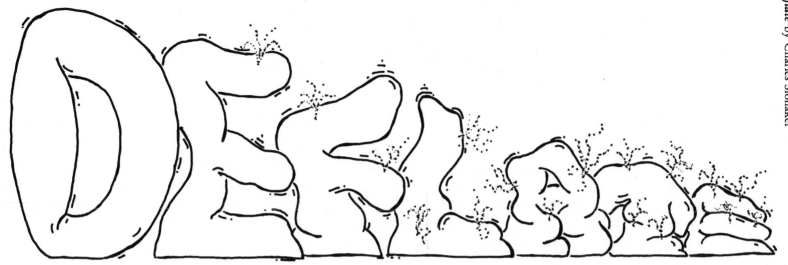

Deflate by Charles Slonaker

DEJA VU

Deja Vu by Mark Soppeland

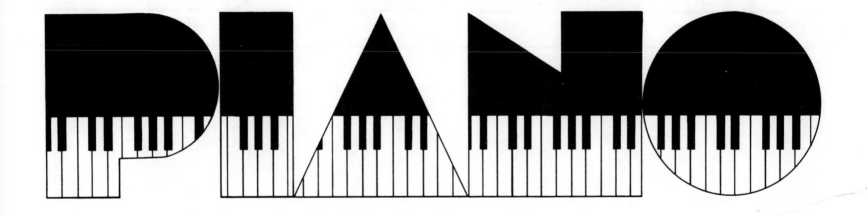

Piano by Robert Williams

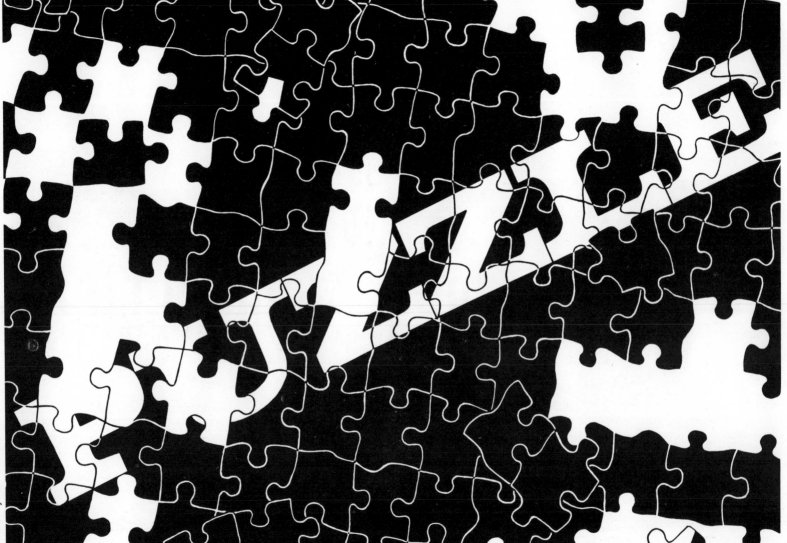

136 WORDS

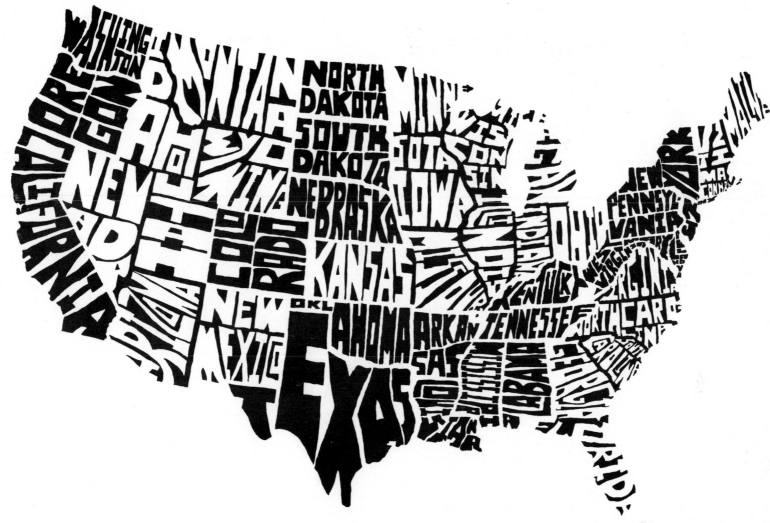

48 States by Scott Mihaloew

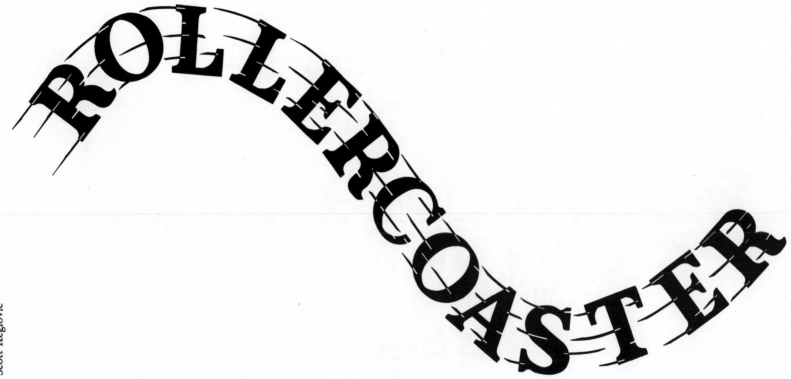

Rollercoaster by Scott Keglovic

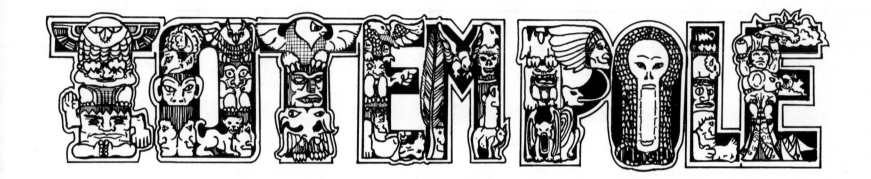

Totem Pole by Robert Kraus

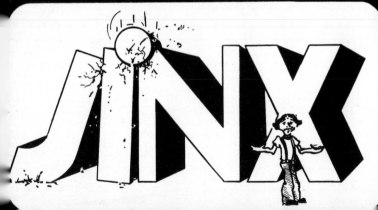
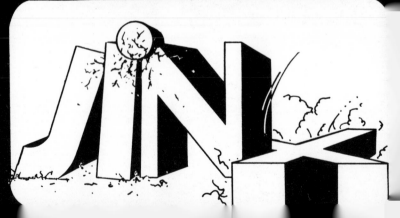

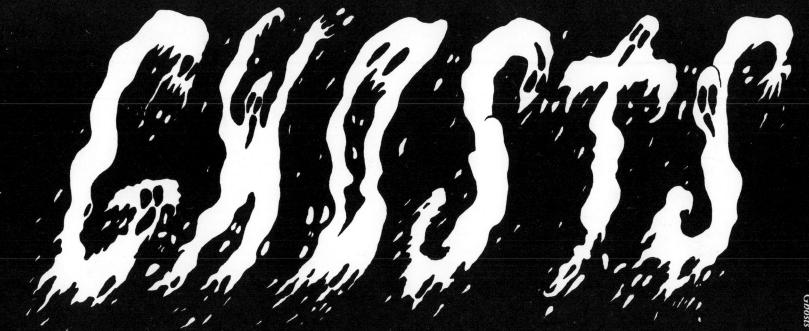

Ghosts by Mark Soppeland

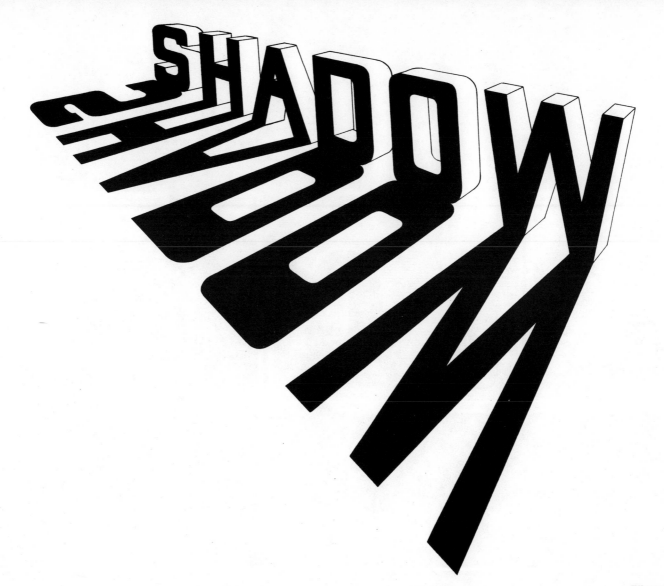

Shadow by Randi Dye

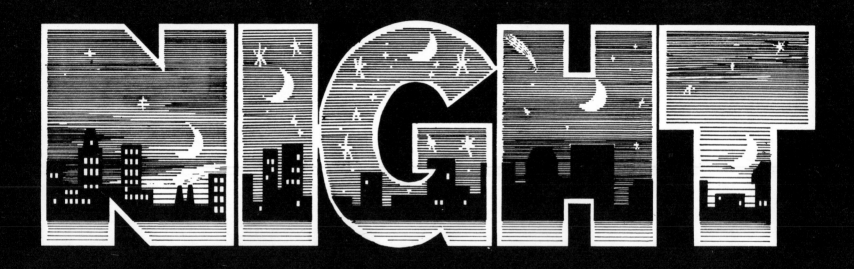

Index

$6.95

"Words are now one of the two largest categories of marketed values that make up the gross national product (GNP)."

—*Ivan Illich, 1980*

WORDS by Mark Soppeland

Evocative, artistic illustrations of more than 150 words—those basic building blocks of the English language—created by Mark Soppeland, University of Akron, and his friends.

"Words, words, words. I'm so sick of words," Liza Doolittle complains in George Bernard Shaw's great play, *Pygmalion*, the inspiration for the American musical comedy, *My Fair Lady*. Well, Liza, here is good news for you: *our* WORDS will bring you health and pleasure! And it will please and delight anyone else who wishes to find new understanding, insight, and visual stimulus from the study of language and imagery.

Words—drawn free of sentence and paragraph—gain style, power, humor and new meaning from the touch of the artist's imagination. Each drawing in WORDS transcends simple lettering, inviting the eye to linger and the mind to con-

template. This is a book for everyone concerned with words and pictures: artists seeking more out of language than mere words, and readers and writers who seek more from words than mere type.

Mark Soppeland is an Assistant Professor in the Department of Art at the University of Akron. WORDS grew out of class assignments in which students were asked to draw and letter words in such a way that they would be artistic, legible and illustrative of their definitions. Soppeland received a Bachelor of Fine Arts degree from the University of Colorado, Boulder, and a Master of Fine Arts from the Ohio State University, Columbus; his works have appeared in more than three dozen exhibitions throughout the country. Off-campus interests include his team of trained seals.

Related Books of Interest

Notes on Graphic Design and Visual Communication

By GREGG BERRYMAN.
A remarkable notebook of essential design information, intended to provide a solid basic "visual vocabulary" and help launch further study of graphic design.
1980; 48 pages; paperback

Rapid Viz

By KURT HANKS and LARRY BELLISTON.
A new mind-expanding drawing technique, providing basic quick-sketching skills that will enable you to capture and convert fleeting ideas into visual form.
1980; 151 pages; paperback

The Universal Traveler

A soft-systems guide to creativity, problem-solving and the process of reaching goals

By DON KOBERG and JIM BAGNALL.
The Universal Traveler is truly a "universal textbook" for anyone who wishes to be a better goal achiever or problem solver.
1976; 128 pages; paperback

Order these books from your bookstore or directly from the publisher.

ISBN 0-913232-60-2

WILLIAM KAUFMANN, INC. • ONE FIRST STREET • LOS ALTOS, CALIFORNIA 94022